FIFTY-FOUR
CONCEITS

FIFTY-FOUR
CONCEITS

A Collection of Epigrams and Epitaphs
Serious and Comic

by MARTIN ARMSTRONG
Wood-engravings by
ERIC RAVILIOUS

UNICORN

Contents

Epigrams I 53

Epigrams II 65

Epitaphs I

A Judge

Many by me, their Judge, when I had breath,
Were to confinement sent to wait their death:
Now breathless I, without the strength to budge,
Lie here confined by Death to wait my Judge.

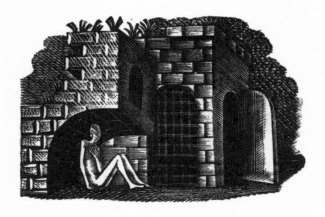

A Young Airman

I loved to slide between the earth and sun,
Laughing at sulky Death, till Death, as one
Who loses patience with a teasing fly,
Brought me to earth and in this earth I lie.

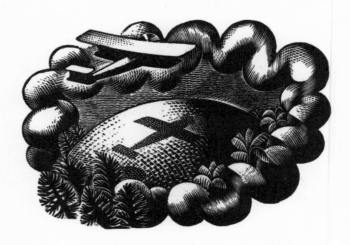

A Suicide

Denied the comfort of your breast,
In the cold sea I sought my rest,
Slowly through twilight deeps to fall
To my unhallowed burial.

An Old Gaffer

In the White Horse, good friends among,
I drank my beer and held my tongue:
Now's closing-time, and lonely here
I hold my tongue but drink no beer.

A Drowned Sailor

Aloft I fought the stinging austral blast
And ripped the roaring sail-shreds from the mast.
Carve not the stone for me nor delve the earth,
Hurled from the mainmast to my soundless berth.

A Chemist

A skilful chemist was I once,
But Death has turned me to a dunce
Witless in formulæ to enmesh
The chemistry of rotting flesh.

A Boaster

Living I blew for many a year
My trumpet into every ear:
Now fearfully I wait below
The trumpet that I shall not blow.

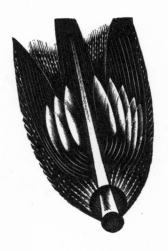

A Watchmaker

With gold and silver wheels I reckoned
Day and night by hour and second:
Sans gold, sans silver now I try
To atomize Eternity.

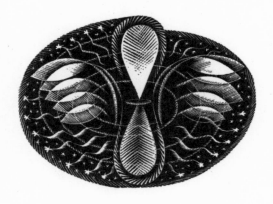

An Explorer

On quaking swamps where tropic fevers burned
I fed my nightly fire, and thence returned:
But from that kingdom which I now explore
The traveller returneth nevermore.

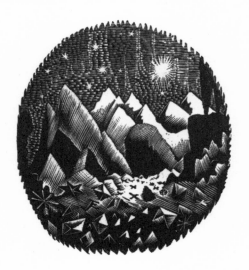

A Misanthrope

Stranger, beware; taste not my cup of gall.
Through hatred of myself I hated all.

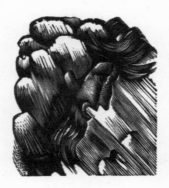

An Athlete

Strong-winded, swift of limb, I could surpass
My fellows at the hurdles. Now, alas,
In wasted legs and breathless lungs there lives
Movement none other than the slow earth gives.

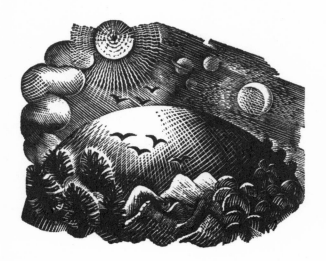

A Crew Lost at Sea

Blown from our course far westward of the Horn
Beneath the Southern Cross we rolled forlorn
Till mastless, rudderless, upon our knees
We found our homeless haven in midseas.

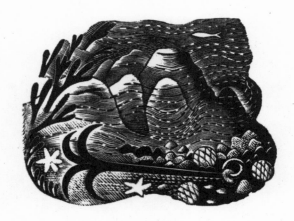

A Coquette

Capricious, vain, by many men desired,
I love withheld until my lovers tired,
But in this narrow bed where now I lie
Adulterous Death possessed me utterly.

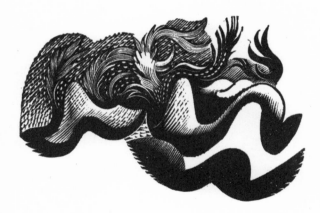

Saint Mary of Egypt

My lot was strange. Let no lewd tongue
 make merry:
I sold my virtue once to pay the ferry.
With virtue saved I had no hope to cross;
I yielded, and there's virtue in the loss.

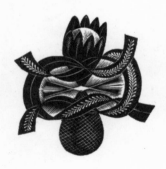

A Soprano

My voice was pure as bird's in spring,
I sang as if I loved to sing,
And still, my lips close-sealed with clay,
I sing in many a heart to-day.

An Only Child

Weep not: I lie not here alone,
Unloved; two others died with me.
Yet they, though I to dust am gone,
Still walk the world and breathe and see.

A Woman who Loved
at First Sight

I loved my mirror, not that it displayed
My pallid cheeks or the sad eyes' deep shade,
But that it showed me once a lovely face
Which now I follow to its resting-place.

A Child that Died at Birth

Out of the peace where she lay curled
She plunged into a wrathful world,
Blinked once her little eyes and then
Into her peace slipped back again.

A Flower-Lover

Of .old between the April showers
I loved to bend above my flowers:
Now April stirs in every tree,
But now my flowers bend over me.

A Sun-Worshipper

I loved the sun and all the sun had made,
Red wine, ripe fruits, and flowers that bloom
 and fade,
And there's a sun-kissed girl I'll not forget
This side of Judgment, though my sun is set.

A Crossing-Sweeper

Long years I laboured in the street
To clear a path for others' feet:
Now sunk in clay I wait to see
Who will clear out a path for me.

A Doubting Priest

To others once I did reveal
The faith and hope I could not feel:
Now here, alone, my candle out,
I nurse my philosophic doubt.

Epitaphs II

A Postman

In wet and fine, o'er vale and hill,
I carried news of good and ill
It was a job as good as most:
Now, I must say, I miss the post.

A Snuff-Taker

Before the fire I loved at ease
To sneeze and snuff and snuff and sneeze.
Doctor declares beyond a doubt
I've gone and snuffed myself right out.

An Old Labourer

Since first I took to pipe and mug
I must have smoked a ton of plug,
And beer . . . you couldn't touch the bottom.
I'm glad I took 'em while I'd got 'em.

A Highwayman

I, many a starry night 'twist Bath and Bristol,
Held travellers up and robbed at point of pistol,
Till jealous Justice robbed me of my hope
And held me up inside a hank of rope.

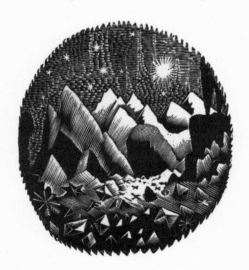

A Nagging Wife

A patient man for twenty years
I harassed to the verge of tears:
Now, by an unintended jest,
I've gone, to his eternal rest.

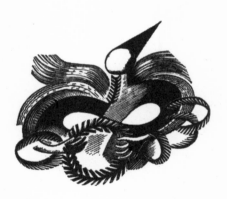

A Tyrannical Father

With rod of iron and a scowling face
I kept my sons and daughters in their place:
To keep me now in mine they do their best
With half a ton of granite on my chest.

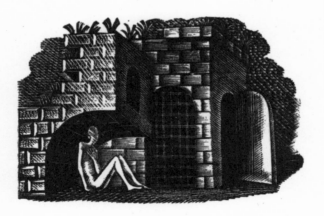

A Famous Tenor

My Walter, Siegfried, Parsifal
Held the whole cultured world in thrall:
As tenor in the Heavenly Choir
I cannot feel I've risen higher.

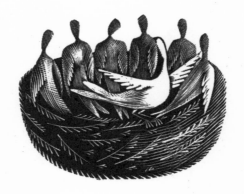

A Joiner who Made his own Coffin

Here lies I, old Joiner Boffin,
 Underground.
None could beat me at a coffin
 Miles around.
A better none was carried off in,
 I'll be bound,
Than this I'm lyin' like a toff in,
 Snug an' sound.

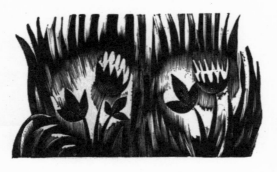

A Fisherman

On Tweed and Till I've wheedled out
Many a crimson-spotted trout:
Then, one cold morning on the Till,
I fished for trout but caught a chill.

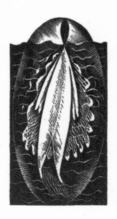

Laudator Temporis Acti

I loathed modernity. Persistent, tireless
I cursed the plane, the motor-car, the wireless.
My relatives, who scorned a dead man's curse,
Rushed me to burial in a motor-hearse.

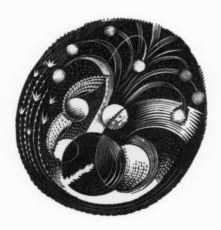

A Lover of Himself and Others

Raised to the peerage, it was said,
By a large heart and swollen head,
Now lies he here, let down again
By gradual softening of the brain.

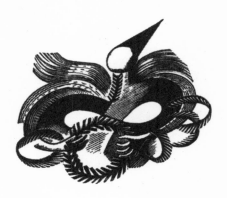

A Bad Playwright

For half a lifetime, day by day,
He tinkered at a worthless play
Till Death supplied the art he lacked
And polished off his final act.

A Bad Novelist

There is a book for every need
So apt that he who runs may read,
But from the volumes I have spun
Whoever tries to read will run.

A Landlady

From '56 till '92
I did for gents and lodged 'em too:
In April of the latter year
Death did for me and lodged me here.

A Boarding-House Liftman

Day by day, from seven to seven
I raised our boarders nearer Heaven
Or, at the summons of the bell,
Dropped them further down to Hell.
Housed here with neither door nor casement
I lie and wonder in my basement,
Teased ever by a lurking doubt,
Where the Last Lift will turn me out.

A Driver of a Mail-Van

Mails I delivered and collected
As promptly as could be expected.
Now that I too collected be,
I pray the Lord deliver me.

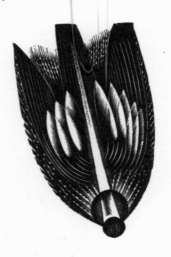

Simple Simon

Teasing boys and girls who saw me
Couldn't help but try to draw me:
Since I rose so often then,
Who can doubt I'll rise again?

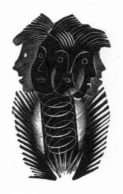

A Wine-Lover

I loved good wine and with good friends made
 merry
On Port and Claret, Burgundy and Sherry,
Till surly Gout stepped in and spoiled our sport.
Portless I lie, though I have come to port.

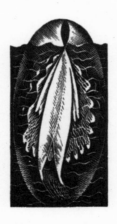

A Scoffer

Dying we come to life, the Preacher saith,
So death is birth and therefore birth is death:
Hence I was born in nineteen twenty-four
And died some five and fifty years before.

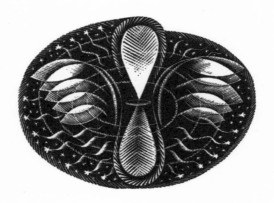

Epigrams I

The Disappointed Glutton

I loved my cook, or rather loved her art,
And to retain the hand I wooed the heart.
Changed to a wife, she scorned to bait the hook
With the divine seductions of the cook.

A False Step

Nancy Trollope climbed so fast
She caught and wed an Earl at last—
A bigamist, so she came wallop
Back to plain and simple trollop.

To a Jilt

Girl, when rejecting me you never guessed
I gave you all the beauty you possessed.
Now that I've ceased to love you, you remain
As once, a creature singularly plain.

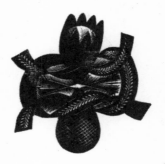

The Virtuous Housemaid

I lets the sweep in at the door;
'E sweeps the flues, I sweeps the floor.
But when 'e starts to pinch and peep
I lifts the broom and floors the sweep.

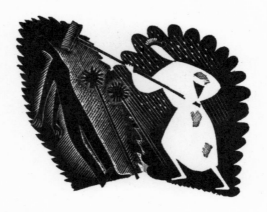

A Cat on her Late Mistress

My mistress turned into a ghost,
I reign supreme and rule the roast;
Yet I cannot claim to be
Half so great a cat as she.

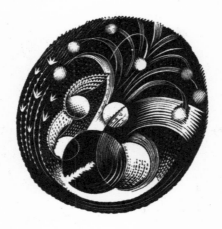

The Patient Impatient

I said to Doctor Tanner
As he took my temperature:
"Pray cut the bedside manner
And get busy with the cure."

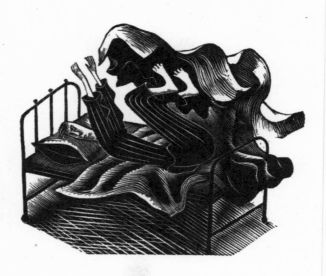

Mushrooms

Mushrooms may prove, when past recall,
Not to be mushrooms after all.
Then why, when vile Sir Vincent Beck
Gobbles mushrooms by the peck,
Should Heaven display reluctance strange
To make the necessary change?

Anthologists

Some folk gather bones and rags
From other people's rubbish-bags:
Then, when they have got enough
Of the miscellaneous stuff,
They peddle round the rag and bone
Fancying it's all their own.

Reviewers

People with a turn for spite
Write about what others write,
And their still more spiteful brothers
Write on those who write on others.
Lord who rulest sea and land
Save us from the secondhand.

Epigrams II

The Self-Lover

Now we've agreed to disagree
It is not you I miss, but me:
Upon myself-in-love to brood
I loved, and you supplied the mood.

The Star in the Pool

A seeing eye, the evening star
And one small pool my parents are.
The offspring not of two but three,
Take one away, I cease to be.

The Reflected Moon

Of God be gotten on the Maid
The Lord was in a manger laid.
Lighting this little pool I lie,
Got on the moon by mortal eye.

Death and the Sculptor

"I build," said one, "by hand and norm,
Lifeless clay to living form."
"I," said the Other, "bruise and bray
Living form to lifeless clay."

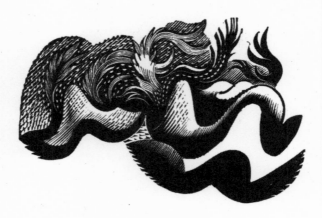